Photographs by Ximena Echagüe

TRAPPED

Daylight

20 YEARS

Cofounders: Taj Forer and Michael Itkoff
Creative Director: Ursula Damm
Copy Editor: Gabrielle Fastman

© 2023 Daylight Community Arts Foundation

Photographs © 2018–2022 by Ximena Echagüe
Post-production: Philippe Leclercq/Limelight Laboratory

Foreword © 2023 by David Campany

ISBN: 978-1-954119-32-1

Printed by Ofset Yapimevi, Turkey

Daylight Books
E-mail: info@daylightbooks.org
Web: www.daylightbooks.org

We are our memory,
we are this chimerical
museum of shifting
forms, this heap of
broken mirrors.

—Jorge Luis Borges,
"Cambridge"

To Gustavo and Selva.
To Valentina.

Edited by Régina Monfort

FOREWORD
David Campany

Is the worst of the coronavirus pandemic far enough behind us to contemplate it without losing our minds? I hope so. We have felt suspended long enough. Our senses of time and place, of history, of purpose and planning, and memory were all scrambled. Maybe they still are.

Sometimes 2020 feels like yesterday. Sometimes it feels like a decade ago. Sometimes I feel as if I have no memories of that time. Sometimes I am overwhelmed by memories, vivid and insistent. I don't know what to make of it all. Are photographs ways of making sense of our lives? Yes, they can be, but it might not be the kind of sense we think we want, or need.

I moved to New York City on March 1, 2020, and walked straight into the pandemic. The door slammed behind me, and I was not able to return to London for fifteen months. New York entered a severe lockdown. I had joined the International Center of Photography, on the Lower East Side, to curate exhibitions, but all galleries and museums in the city were forced to close. ICP launched a hashtag, #ICPConcerned, inviting our followers to make and upload images of whatever was going on in their lives around the world.

This is when I started to see images by Ximena Echagüe. It was clear to me straightaway that she was a smart, playful, and empathetic observer of life around her. She had a hungry eye, and it was learning to see this new pandemic world with all its strangeness, fear, and anxiety, along with its unlikely moments of hope and humanity. ICP began putting together an exhibition of the hashtagged images.

I chose one by Ximena that touched me so deeply I was tearful. A night shot of a lone figure in a high-rise building, in silhouetted profile, in a room bathed in red light, looking out across the silenced, blackened city. In the distance, red light atop the Empire State Building. Ximena had written a caption: "Street photographer without streets / The new plague has confined us all indoors, allowing only for introspection, imagination and symbolism to capture the new fuzzy reality, the invisible risk, the permanent fear."

New York is always a theatrical city, performing itself, for itself. During the pandemic a sense of the theater of everyday life seemed at times subdued and other times more intense. An empty city can be as dramatic as a full one. A face made blank by confusion can be as dramatic as joy or anger.

Ximena's photographs seemed to be responding to all of it, in the moment, without judging. The great thing about photography is that you don't have to know exactly what you think about what you are looking at, what you are photographing. Ximena seemed to be able to compose her frame and press the shutter at moments when mixed feelings were at their most acute. Her images are not "messages." They are occasions to revisit the confusion, the not knowing, the doubt. They make me feel as if the pandemic, as we lived it, was like a photograph: frozen and silent, explaining nothing, but full of clues and possibility.

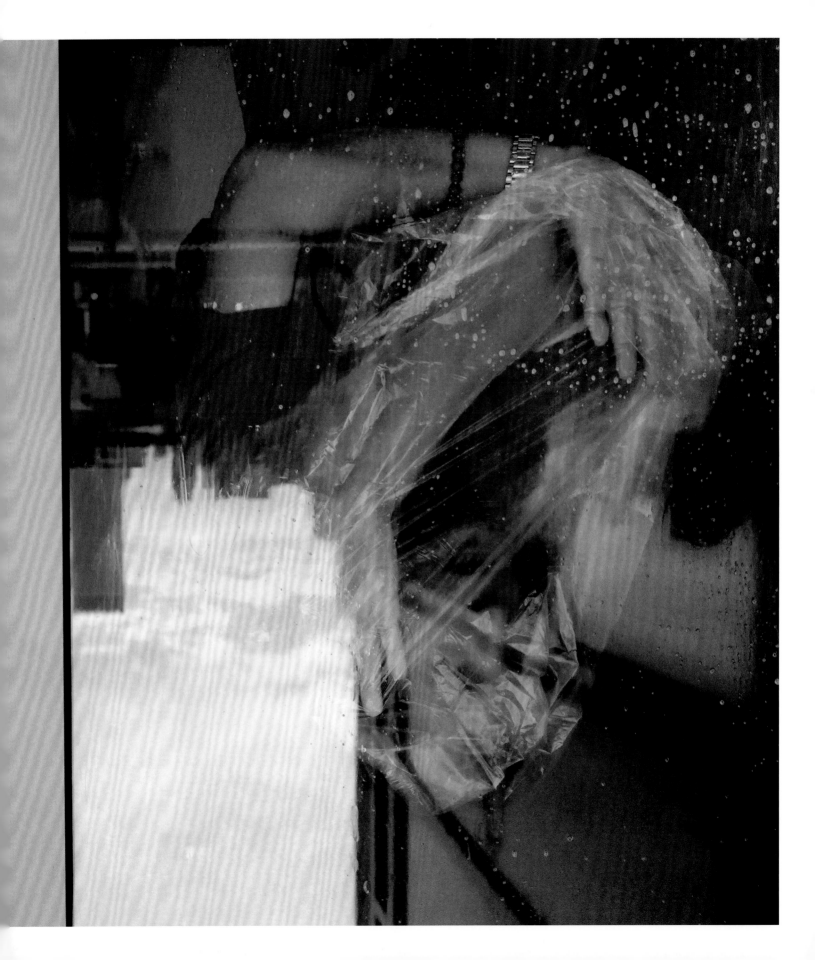

We are
committed
to the health
and safety of our
customers and
our employees

This Microsoft Store is closed due to
COVID-19 health concerns to help
protect the health and safety of our
customers and our employees.
During this unprecedented time, the
best way we can serve you is to do our
part to help minimize the risk of the
virus spreading. We will re-open as soon
it is safe to do so.

In the meantime, we look forward to
serving you online at microsoft.com

Microsoft #MicrosoftNYC

Surface Laptop Surface Laptop

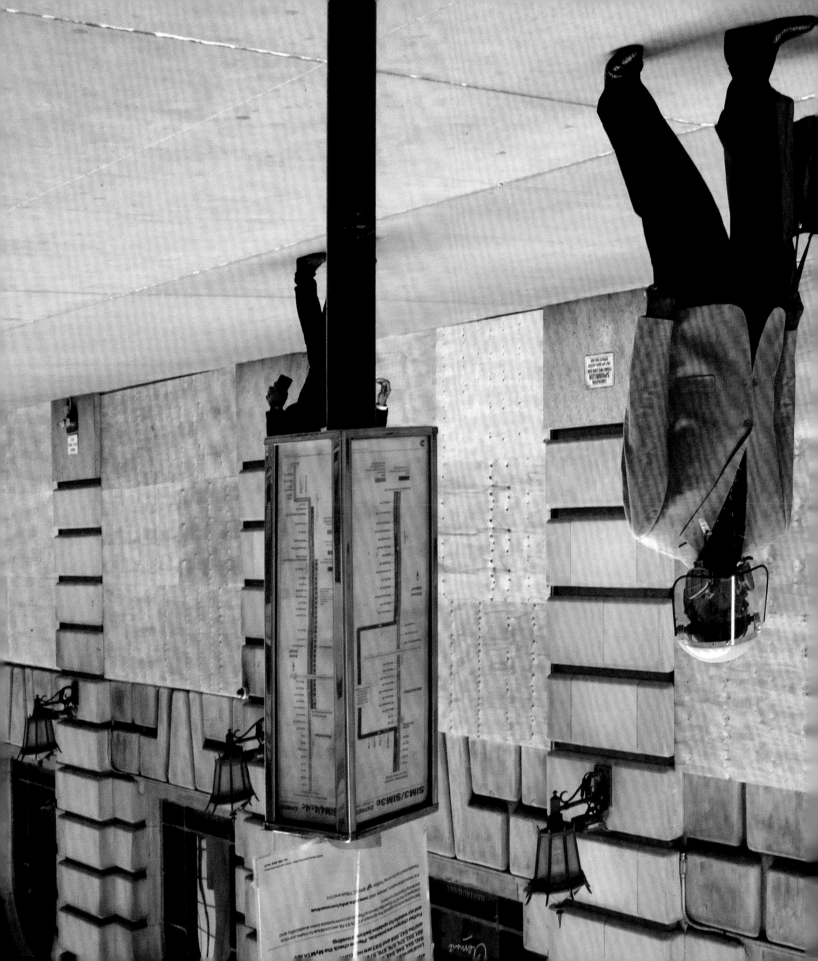

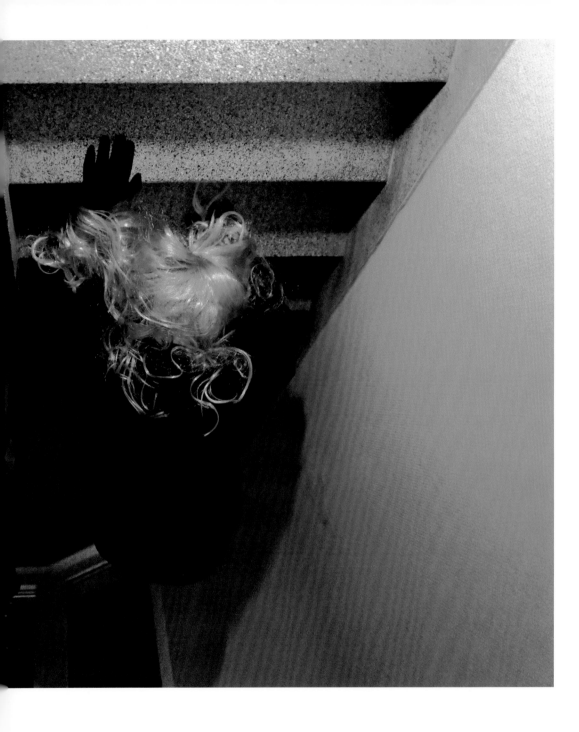

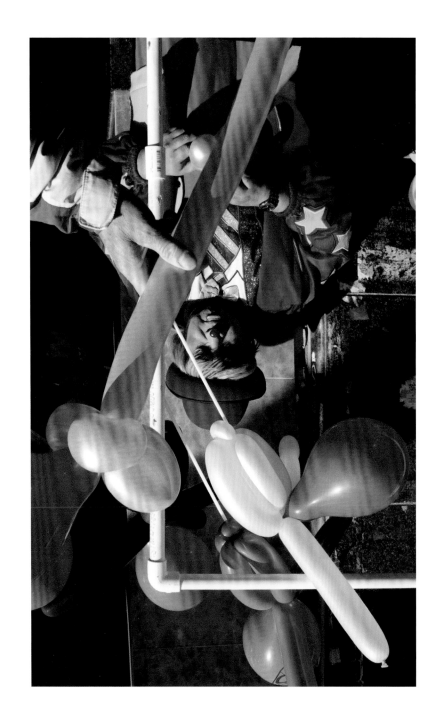

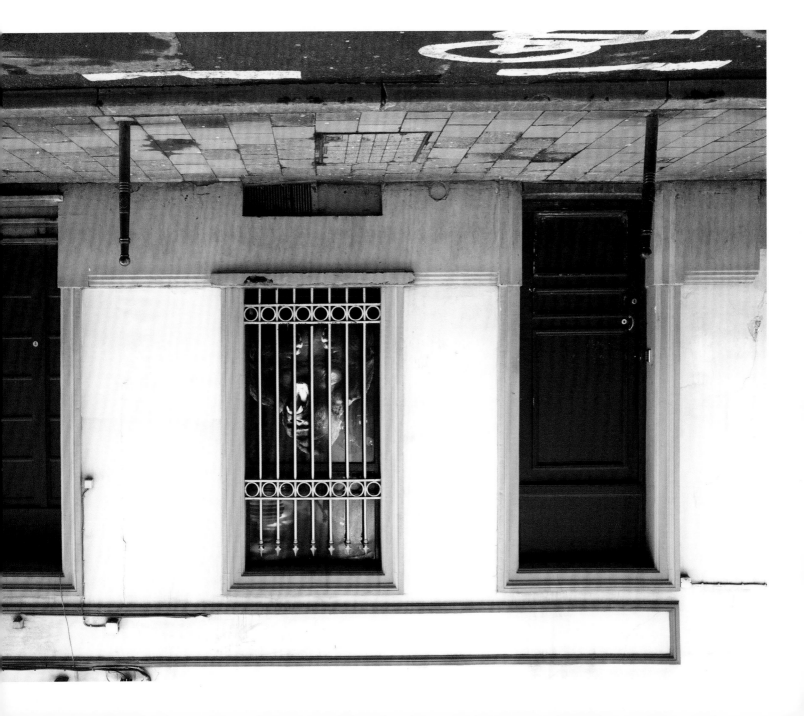

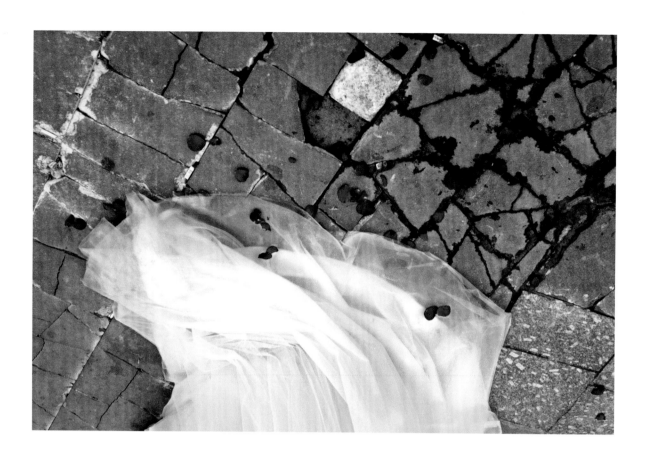

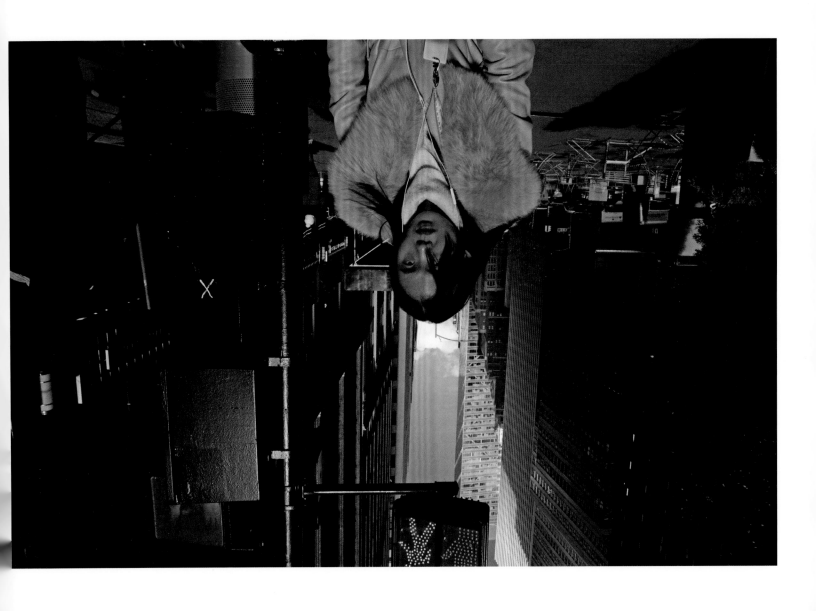

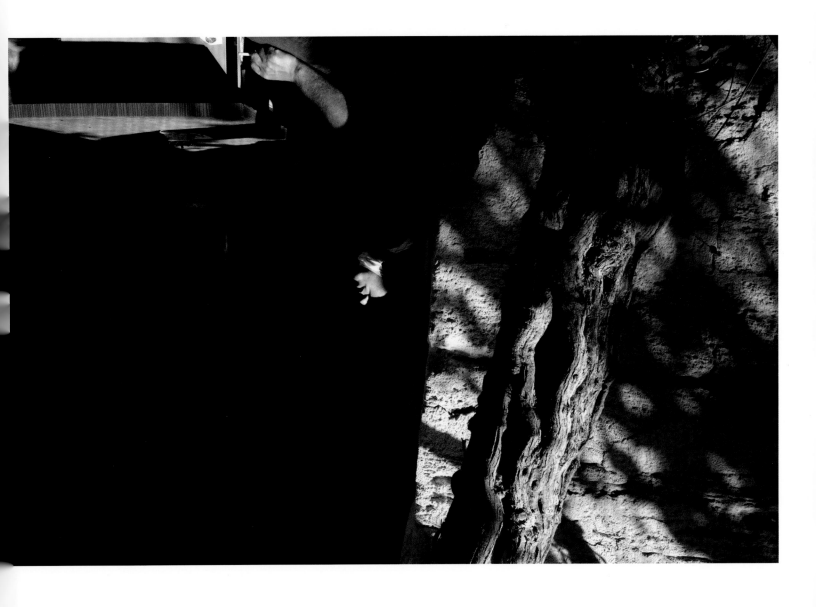

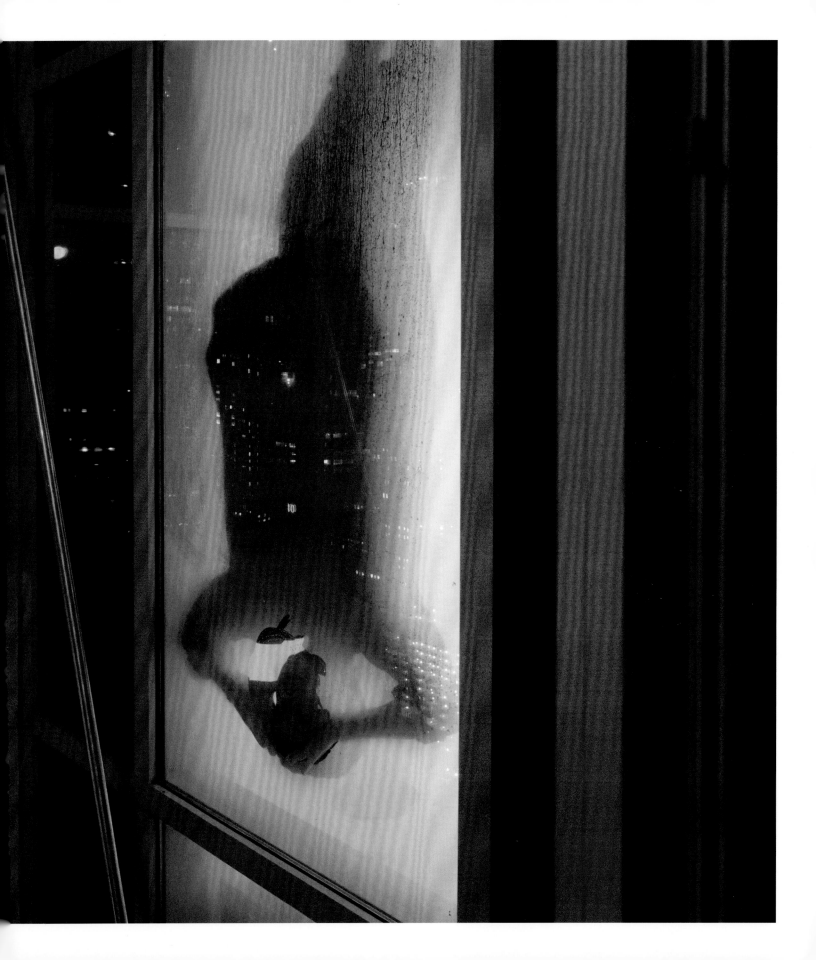

AFTERWORD
Ximena Echagüe

I have always tried to capture human dynamics in my photography, made of hopes fulfilled or shattered, with its drama and contradictions, the odyssey of human life.

This book is the result of a personal journey over several years during which our lives were turned upside down, most certainties vanished, many cherished ideals were challenged, and our most basic habits and freedoms were questioned.

We have been living through eerie times. Life is no longer what it used to be, and we are all struggling to overcome a deep unease, a feeling of being trapped in an existence full of contradictions we no longer understand or control.

The photos in this book capture this fuzzy new reality. They are glimpses into troubled souls trying to make sense of the unknown. They reflect emotions, fears, confusion, and anger but also resilience, irreverence, strength, and humor. There is a before-and-after feeling in them, a sense of having turned a page into something new still being formed, shapeless and blurred.

It all started for me when moving from (Brexit) Europe to (Trump) USA: two polarized societies where truth was no longer a shared value. Two years later, in New York, the pandemic sent all of us into sudden lockdown for months; our lives were interrupted and our plans became irrelevant.

When I managed to go back to Europe, in an almost empty plane, I had to face yet another long lockdown, followed by the horrors of war in Ukraine and the social consequences of all these events, including a sharp increase in inequalities and social unrest. My old world looked and felt different.

The pandemic, tragic as it had been, was just the background of this journey. Its consequences, together with the other disruptions, had irreversibly altered our lives. It had forced all of us to live with anguish and constant fear of the unknown, the invisible risk, without contact with others. We were no longer masters of our own destiny. Our lives hung by a fragile thread, and obscure scientific concepts became our new daily diet. Even the most banal human interaction had become dangerous; "keep your distance" was the new mantra.

As a street photographer I had no option but to reinvent myself through self-portraits that aspired to capture how I felt in this surreal world. Streets were empty, the noise of ambulances was constant, the great city had become a ghost town. We didn't know at the time that the pandemic, and its consequences, would last so long. Perhaps not surprisingly, my photography became introverted, symbolic, and imagination was all that was left to replace our noisy and hectic existence. Emptiness suddenly had a meaning, and shadows were full of opportunity; even balloons adrift carried a new significance.

When the streets of New York erupted in the Black Lives Matter movement, we felt as if, finally, we were alive again. But quickly windows were broken and shops walled up, creating yet another visible barrier, a new fractured landscape, another reason to reflect on a divided society. The pandemic had exacerbated social injustices; the main victims were the usual ones, those so-called essential workers who were glorified and even applauded for a short while but soon went back to their anonymous existence.

These lockdown self-portraits allowed me to come across David Campany and be part of the fascinating ICPConcerned exhibition he curated in New York. He has been kind enough to write a foreword for this book, for which I am very grateful. My street photography during the pandemic was exhibited by the Museum of the City of New York for their New York Responds reopening and also features in this book. Both themes, concern and response, or anguish and resilience, are very much at the core of this story.

This is also a story of human resourcefulness and solidarity, a journey into how humanity struggled to survive fear and overcome many challenges. Whether in New York or Brussels, Istanbul, Madrid, or Buenos Aires, life went on and people found ways to cope and even thrive, showing unabated optimism and sometimes irrepressible humor. I have always looked for the quirky and funny in the midst of the gloom.

I hope the result captures in a very personal way how we have all felt over the last few years, not only trapped in uncertainty but also full of life and hope. It aims to raise questions rather than provide answers or explanations. Humanity will never cease to surprise me.

ACKNOWLEDGMENTS

Any book is the result of many years of work during which countless people inspire, help, and support you. Thanking some of them always leads to unfairly forgetting many who certainly deserve being mentioned. Aware of this, I will only mention a few who have accompanied me closely during this journey but will also extend a big thanks to all the many friends and colleagues who, although remaining anonymous, know very well how important they are to me and to my work.

Starting with those who appear in this book, a big thanks to David Campany for his foreword and inspiration, and to Régina Monfort for her amazing editing skills and sound advice. David's ICPConcerned exhibition in New York was instrumental in making me start to think about such a book. Régina, whom I met in Wilson, North Carolina, and who came back to live in Europe at the same time as me, was someone who always believed in this journey and was able to help me make sense of it.

Many photographers deserve a mention, but I will limit myself to Gulnara Lyabib Samoilova, dear friend and founder of Women Street Photographers, which has been my home during my time in New York. Vineet and Rohit Vohra, my street-photography friends with whom I spent unforgettable moments during two Melas in India, and also Eric Kim, Matt Stuart, David Gibson, and Nick Turpin, whose workshops over several years have expanded my photographic horizons.

And of course, other great photographers and friends such as Kevin Scarlett, who worked on the first cover tests, Andrea Torrei, Céline Pannetier, Suan Lin, Valérie Six, Margarita Mavromichalis, Linda Troeller, Gökhan Arer, Silvia Hagge, Graciela Magnoni, Gloria Salgado Gispert, and Alicia Haber.

I have found in Daylight a wonderful publisher, and my thanks go to Michael Itkoff, Sam Darby, Ursula Damm, Gabrielle Fastman, and Andrea Smith for their professionalism and support. Additional thanks to Philippe Leclercq, from Limelight Laboratory in Brussels, for his time and dedication to the post-processing of the images.

I can't fail to mention my dear Jérome Le Sauvage who showed me "the way" and Valentina, my life sister and soul mate, that I miss so much and with whom we would have celebrated this book. Special thanks also to Carolina and Anno, my muses during these uncertain times, for their personal collaboration.

Finally, such a long journey always requires family support and affection; otherwise, it becomes a very lonely adventure. My mother, Selva, was always there with her keen journalistic eye and unconditional love. My children, Josefina, Juan, and Mora, have always believed in me, and their support and understanding is irreplaceable to me.

Last but not least, special thanks to my life partner, Gustavo; all of this would not have been possible without him.